France

France

Inspiration du Jour

An Artist's Sketchbook
by Rae Dunn

CHRONICLE BOOKS
SAN FRANCISCO

Library of Congress Cataloging-in-Publication Data

Names: Dunn, Rae.

Title: France : inspiration du jour / by Rae Dunn.

Description: San Francisco : Chronicle Books, 2017.

Identifiers: LCCN 2016010284 | ISBN 9781452153650 (alkaline paper)

Subjects: LCSH: France—Pictorial works. | Paris (France)—Pictorial works. | France, Southern—Pictorial works. | Dunn, Rae—Travel—France. | Artists—Travel—France. | Creation (Literary, artistic, etc.) | Inspiration. | France—In art.

Classification: LCC DC20 .D86 2017 | DDC 914.40022/2—dc23 LC record available at http://lccn.loc.gov/2016010284

Manufactured in China

MIX
Paper from
responsible sources
FSC® C008047
www.fsc.org

10 9 8 7 6 5 4 3 2 1

Chronicle Books LLC
680 Second Street
San Francisco, California 94107

www.chroniclebooks.com

I dedicate this book to my dad, whose curious mind, excitement
for trying new things, and openness to inspiration everywhere
shaped who I am today. His pure and simple exuberance for life
was true joie de vivre.

La Figue.

Foreword

Sometimes, something good can come from something bad.
This happened to me in 1993. While traveling through
Spain, my camera was stolen out of my backpack as I
was getting off a train in Málaga. I know exactly how it
happened. The man pushing me from behind grabbed it as we
headed toward the door, almost in slow motion, but I was
too tired and confused to react, and thought he was just in
a hurry to get off the train. It wasn't until I was in the
train station that I realized what he had done. The pouch
zipper on my backpack was open and my camera was gone.
This loss soon became my gain.

I have always carried a journal with me, but on this trip,
the journal soon became a sketchbook. I felt I had no
choice. In order to remember the things that I wanted to
remember I quickly drew sketches of them in lieu of taking
pictures. I did not go to art school, never took a drawing
or painting class, and didn't think I could even draw very
well. But this pivotal event opened up a new way for me to
see the world and to document my journeys.

Imagine a life without any recording devices. These days
we rely so heavily on our cell phones, our cameras, our
video equipment, anything to record an image hoping to
capture something that will stay with us forever. In
Spain, when this technology was taken away from me, I had
to rely on my own devices: my eyes, my hand, a pencil. A
camera, of course, is a very important and necessary tool,
but I learned that when I drew something that inspired me,
I remembered it more viscerally than if I had just pushed
a button. It is a much deeper connection to the object and
a more soulful experience.

These sorts of things have always been important to me.
Growing up, I knew for certain that I would somehow work
in a creative field, and I eventually chose graphic design.
This was the pre-computer, pre-internet era when things
were truly done by hand. But the design world was quickly
turning toward technology and soon I lost interest. It was
by complete chance that I discovered clay when I signed
up for a ceramics class by flipping a coin. Heads: stained
glass, tails: ceramics. It was then and there my fate was

sealed. The minute I first touched clay, I knew I had found my voice, and since 1994 it has been my life.

For the past four summers, I have done a residency in the South of France to further explore my work with clay. I began each day by running to the Mediterranean Sea for a swim. Mornings were spent in the studio and afternoons were for traveling, exploring, observing, and soaking up the inspiration of France. I was always armed with my sketchbook and my camera to document these journeys.

I am immensely inspired by the colors, the food, the landscape, and the culture of France—both Paris, where I first arrived, and the South of France, where I spent the bulk of my time. What you will find in these pages are my impressions, thoughts, and inspirations from my time there—captured in my sketchbooks in words, photos, and drawings. I have been fortunate enough to travel all over the world but I feel particularly connected to France because I share the sensibilities, aesthetics, and quality of life of the French.

My sketches are literally drawn in seconds, often while walking, traveling in a car, a train, or even on a bicycle. It is not my goal to draw the object perfectly or to represent an entire scene the way a camera would—et voilà, I just use my camera for that! I'm merely trying to quickly capture the essence of an object, a moment, a feeling, an inspiration. Drawing with precision is not important to me, it is simply my interpretation of what I see, feel, and choose to remember.

I invite you to peek inside my sketchbook and join me on my journey through France. . . .

my south of france wardrobe.

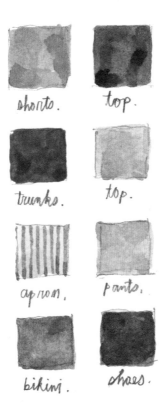

shorts.

top.

trunks.

top.

apron.

pants.

bikini.

shoes.

i packed the MINIMAL amount
for my residency in vallauris.

landed in PARIS at 7:30 a.m.

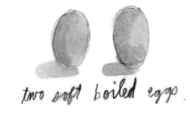

two soft boiled eggs.

toasted bread crusts.

fresh squeezed orange juice.

went straight to MeRCi
and ate this breakfast.

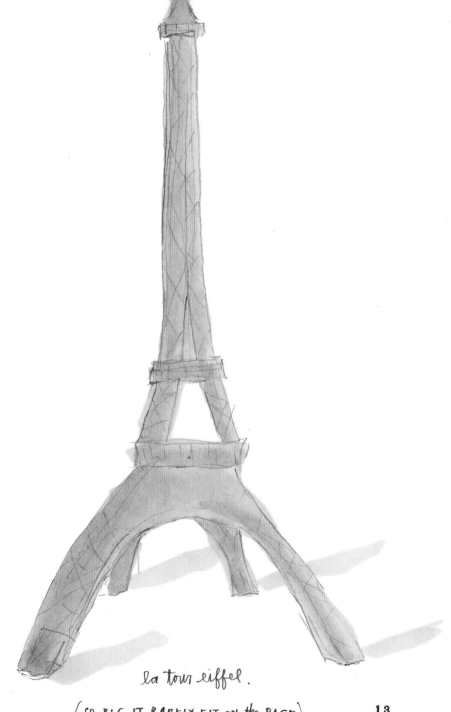

la tour eiffel.

(SO BIG IT BARELY FIT ON the PAGE)

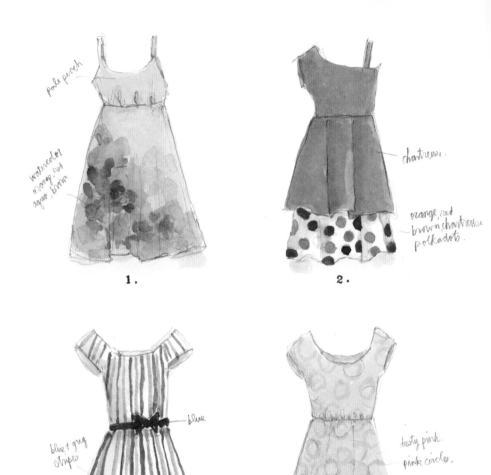

pale peach

watercolor
orange, red
aqua, brown

1.

chartreuse.

orange, red
brown chartreuse
polkadots.

2.

blue + grey
stripes

blue

3.

dusty pink.
pink circles.

brown
stripes.

4.

JauNty DreSSeS iN tHe WiNDOW
oF aNNe ELiSaBetH.

raspberry

yellow

tan

tartelette citron.

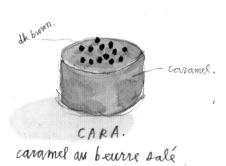

dk brown.

caramel.

CARA.

caramel au beurre salé.

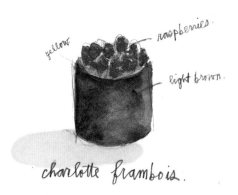

yellow.

raspberries.

light brown.

charlotte framboise.

A QUICK STOP FOR SOME SWEET INSPIRATION.

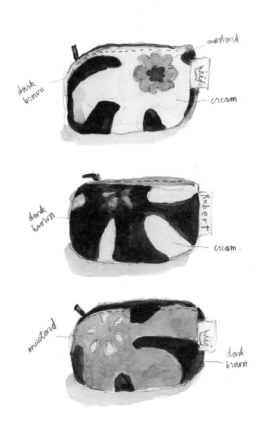

SO MANY CUTE POUCHES AT
the ROBERT le HÉROS SHOP.

I COULDN'T DECIDE WHICH ONE TO BUY...
SO I BOUGHT ALL OF THEM.

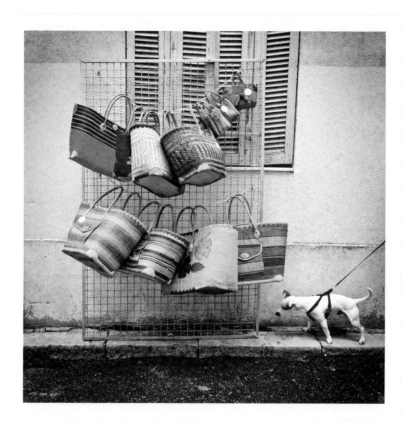

le petit chien was drawn to these bags
as much as i was.

this is MY kind of french graffiti.

Jardin du Luxembourg.
(STATUES OF FRENCH QUEENS and ILLUSTRIOUS WOMEN)

sainte clotilde.

la reine mathilde.

marguerite de provence.

berthe ou bertrade.

sainte bathilde.

marie stuart.

marguerite d'anjou.

marie de médicis.

marguerite d'angoulême.

valentine de milan.

anne de beaujeu.

blanche de castille.

anne de bretagne.

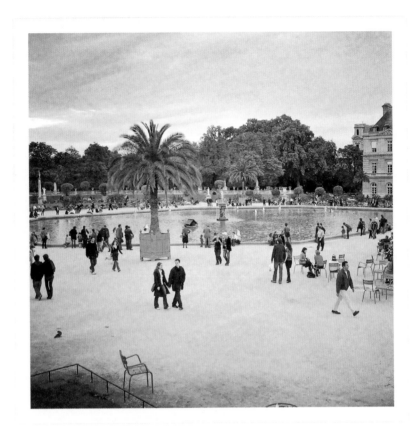

an impressionist afternoon at le jardin
du luxembourg.

i aDoRE

AHe sCaTTeRiNg

of gReeN cHaiRs all tHRoUgHoNT

Le JaRdiN du LuxeMBouRg.

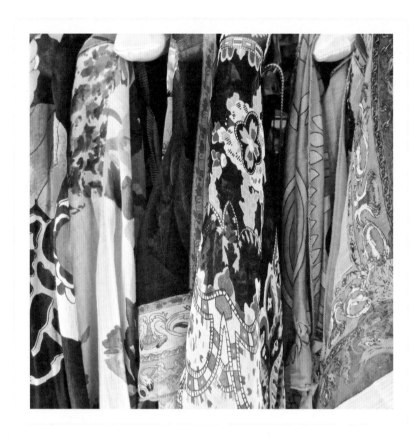

vibrant hues of french silks.

PICASSO

13

ETAT LIBRE D'ORANGE
PARIS

Find the scent that calls your name.
etatlibredorange.com • 69 rue des Archives Paris 3e

S 17
10 F

€ 3.20
032124

ZERØ
DOLCIFICANTE IPOCALORICO

RATP SNCF
PARIS
AEROPORTS CDG

2 cl

J0566013 LUX. B 1

Cette Bouteille porte le N° 126898
MIS EN BOUTEILLE
J.L. QUINSON
E-THORINS

Gym
MOUTARD
MOSTAR
MÖSTER
SENF
MOSTAZ
SENAPE
MOSTARD
MUSZTARD
خردل

A consommer Da
ds préférence di pre
avant le :
Prod. & Exp.date Najlepiej spoży
T.H.T. استهلاك قبل
Mindestens haltbar تاريخ
Caducidad :

il caffè degli amatori

FLORIO

Fromage de
Chèvre Fermier
à la Pâte d'Olive
Au Lait Cru

AB
AGRICULTURE
BIOLOGIQUE

CERTIFIÉ
Certifié
ECOCERT sas
F.32600

Alain Barbagli - 06910 Amirat
Tél. 04 93 05 60 74 - www.lafermadaqui.com
Produit issu de l'Agriculture Biologique
Ing: Pâte d'olive 20 gr env.
Mat.gr : au lait entier

Fr
06.002.001
CE

FROMAGE de CHÈVRE FERMIER
au LAIT CRU

I. DUCASTEL
&
S. FANARA

FR
06.T15.003
CE

LE SANTON

M.G. au lait entier • 06260 SAINT ANTONIN • 04 93 05 60 11

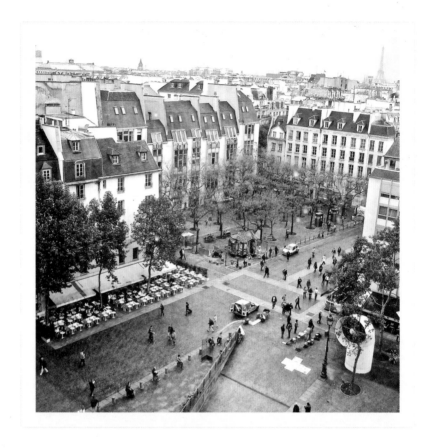

good people watching atop
the pompidou.

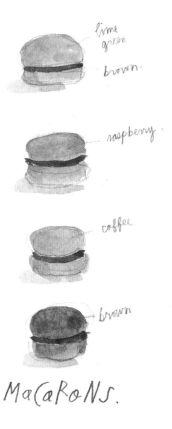

lime
green

brown

raspberry

coffee

brown

MaCaRoNs.

this SWeeT sugar packet.

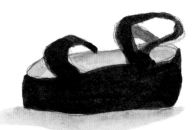

i wanted these shoes.

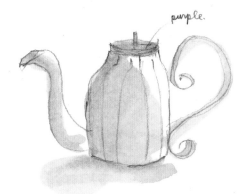

purple.

teapot at mariage frères.

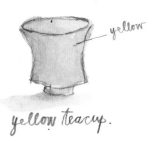

yellow

yellow teacup.

orange

green w orange polkadots

blue
green

blue + green

wine
blue.

bright mustard.

wine + blue

red w yellow polkadots.

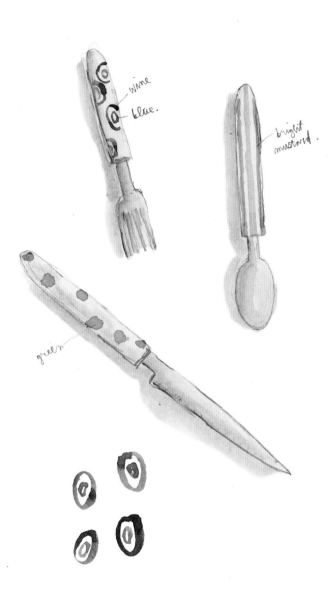

green

green

green + white

red

red + white

blue.

blue + white

wine

wine + white

COLORFUL CUTLERY
at L'eCLaiRegUR.

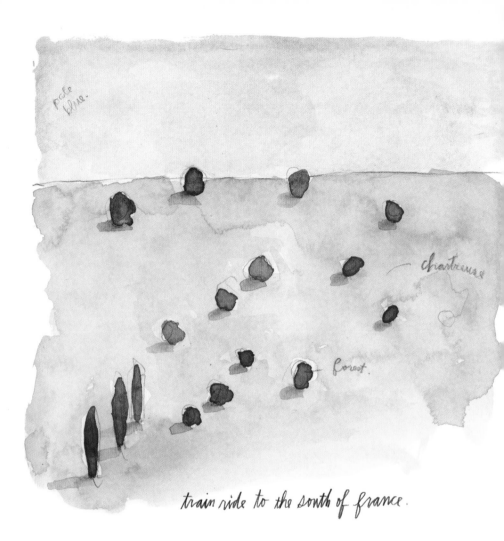

pale
blue.

chartreuse

forest.

train ride to the south of france.

forest

chartreuse

yellow

forest

forest green

pale blue

brown

brown

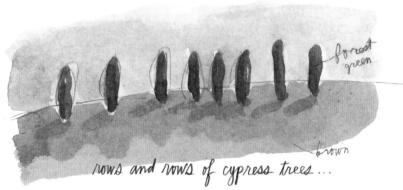

forest green

brown

rows and rows of cypress trees...

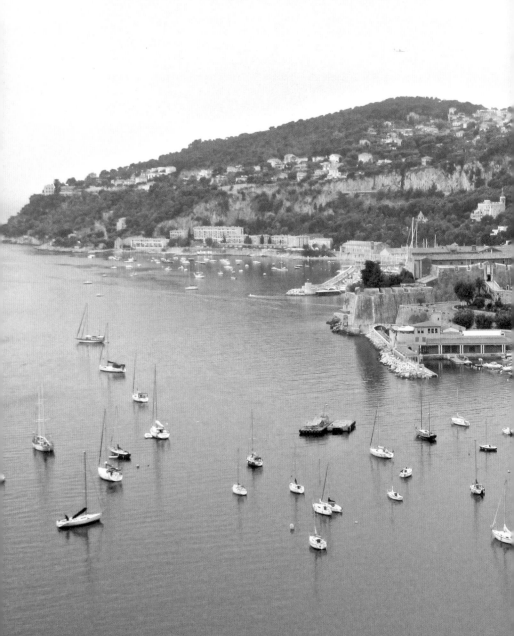

made it to the South of France...

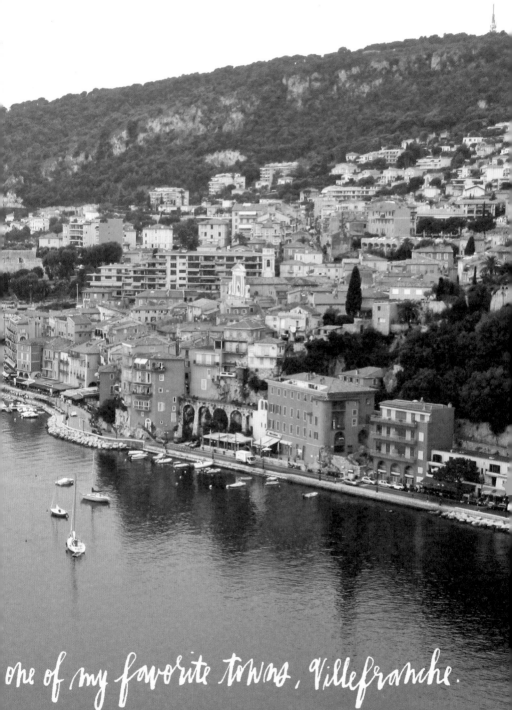

one of my favorite towns, Villefranche.

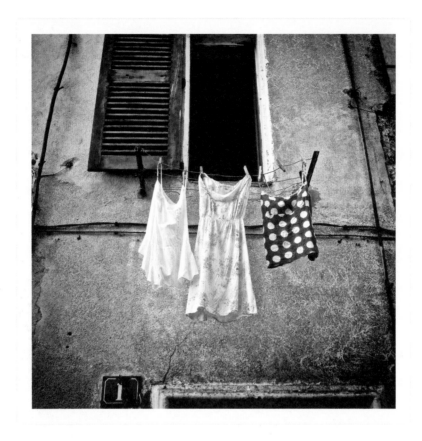

i've arrived.

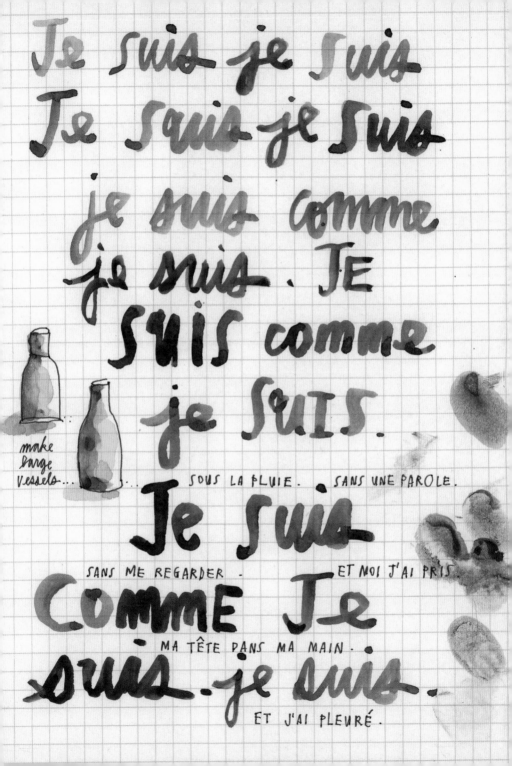

Je suis je suis
Je suis je suis
je suis comme
je suis. Je
suis comme
je suis.

make
large
vessels...

SOUS LA PLUIE. SANS UNE PAROLE.

Je suis

SANS ME REGARDER . ET MOI J'AI PRIS.

COMME Je

MA TÊTE DANS MA MAIN.

suis je suis.

ET J'AI PLEURÉ.

many blues of the mediterranean.

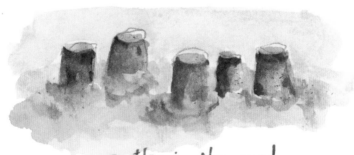

castles in the sand.

french riviera sand.

beautiful creatures frozen in time.

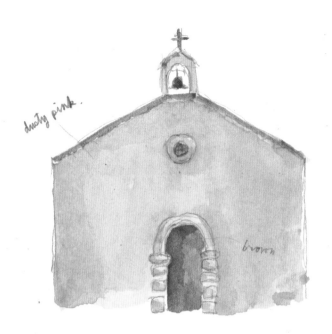

dusty pink.

brown

the charming chapel in our square.

CHAPELLE de LA MISÉRICORDE.
built in 1664

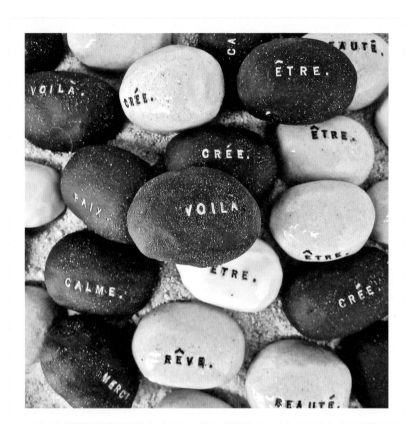

testing some of my french clays.

tan

black.

lisa's shoe.

black

my shoe.

WE WALKED MANY KILOMETERS DOWN the FRENCH RIVIERA TODAY.

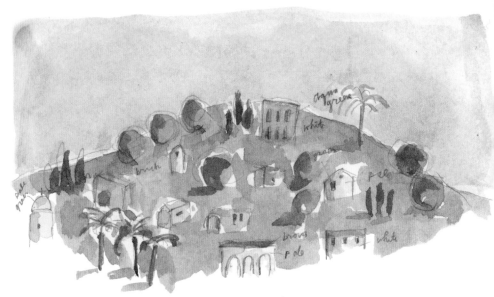

the hills of golfe-juan.

ALLO

CENTRALE TAXI

GOLFE-JUAN - VALLAURIS

ENGLISH SPOKEN

Plusieurs taxis, un seul N°

04 93 64 01 01

un petit pique-nique.

brown light

such an <u>ENORMOUS</u> blueberry.

(this was the actual size.)

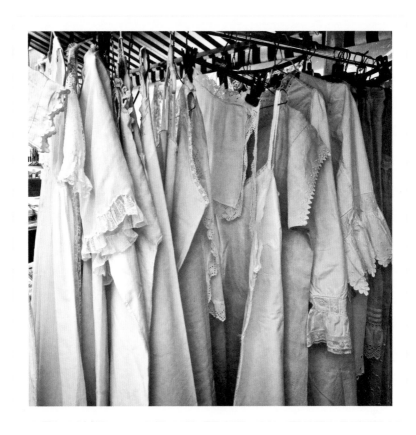

linen frocks at the flea market.

white
cream.

LUNCH @ the ROTHSCHILD TEA HOUSE TODAY.
such fancy curtains.

the wishbone from our roasted chicken.

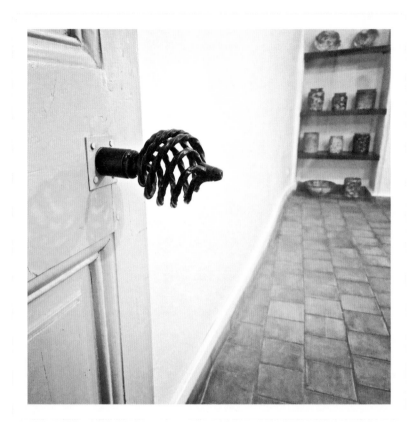

at the picasso national museum in
vallauris, even the doorknobs are
works of art.

an old key i bought at a
fled markett in golfe-juan.

1 euro.

orange.

brown

tapenade.

pink.

jambon.

caviar.

chèvre.

yellow

muddy
yellow.

thon.

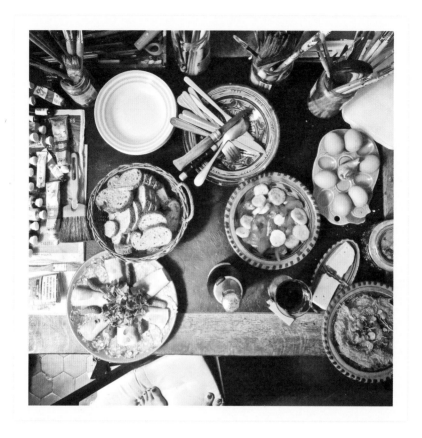

une bonne soirée chez jean michel.

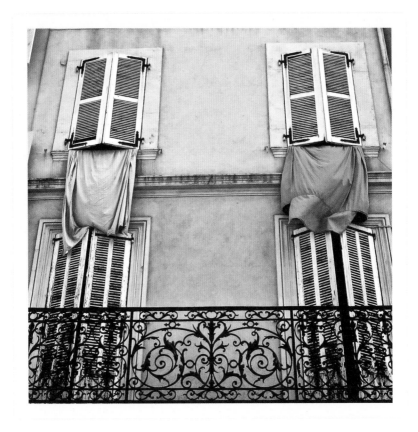

the distinct beauty of french laundry.

ÉTUDE de POIRE.

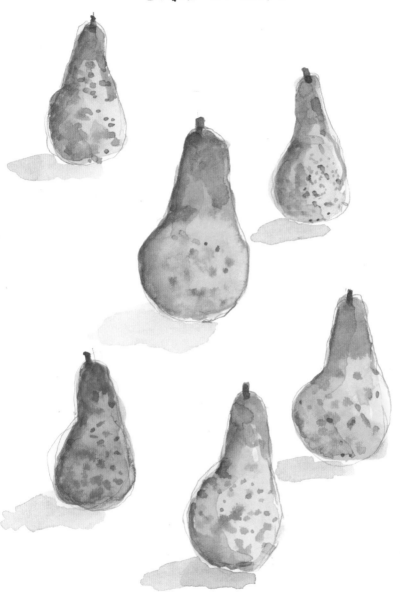

THIS WAS A PERFECT PEAR THAT I
PAINTED QUICKLY SO I COULD EAT IT.

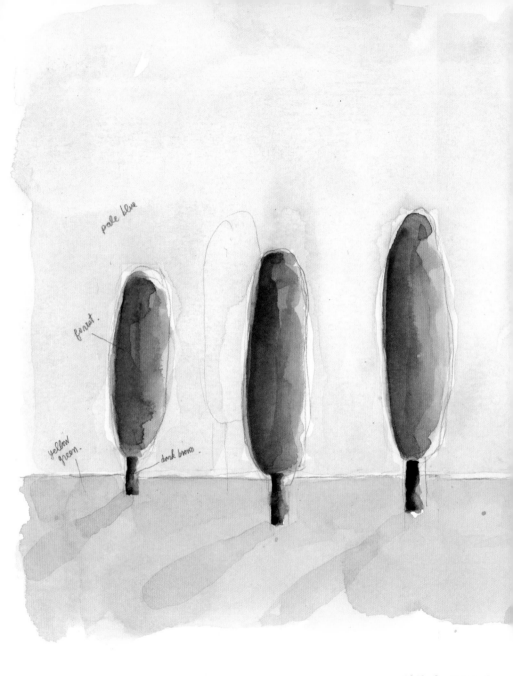

pale blue

forest.

yellow
green.

dark brown.

so MANY

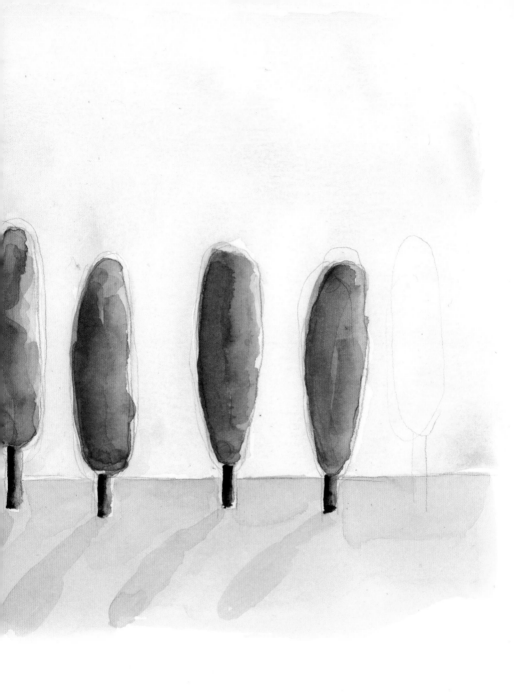

cypress trees.

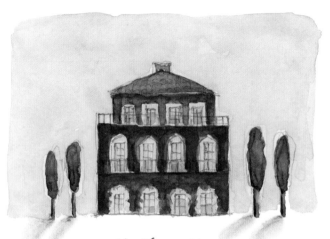

MUSÉE MatiSSe.

paint chip from the wall of the
matisse museum.

(it was starting to peel off anyway)

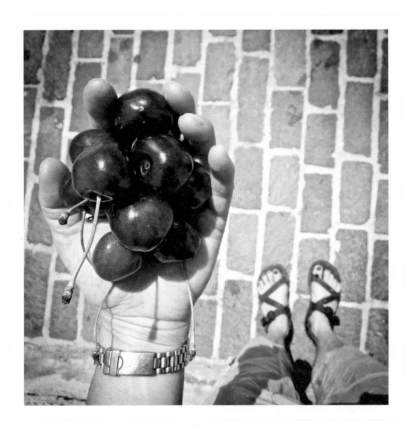

these large cherries from the farmers
market were the same color as the
matisse museum.

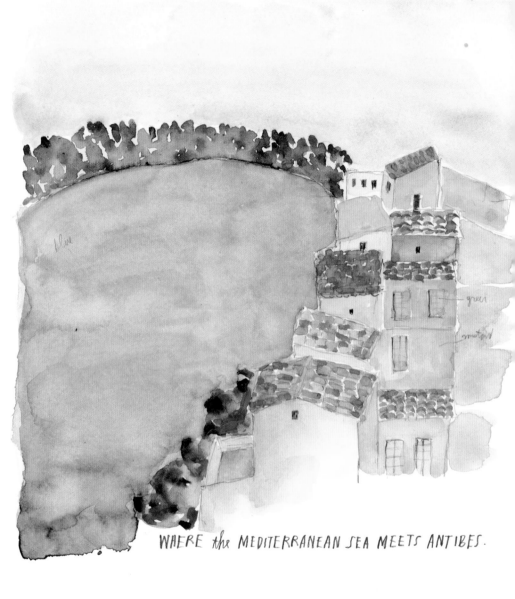

WHERE the MEDITERRANEAN SEA MEETS ANTIBES.

a delicious ice cream bar.

the STICK.

this coffee cup was sitting on the
kitchen table, not even trying to be
beautiful. . . . it just was.

THIS IS ONE OF the BEST BOTTLES
OF ROSÉ I HAVE EVER HAD...

love the
cloudy glass.

CHATEAU RASQUE

2013 *2013*

Cuvée Alexandra

CÔTES DE PROVENCE
APPELLATION D'ORIGINE PROTÉGÉE

13% vol

75 cl

MIS EN BOUTEILLE AU CHÂTEAU
SCEA DU CHÂTEAU PROPRIÉTAIRE-RÉCOLTANT
83460 TARADEAU - FRANCE - PRODUIT DE FRANCE

Contient des sulfites et protéines de lait

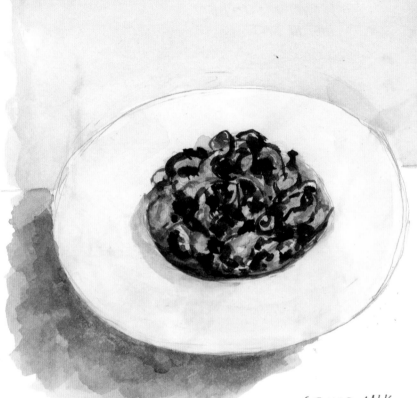

I ATE THE MOST AMAZING SQUID INK
PASTA IN NICE AT LA BARQUE BLEUE.

the ink was SO black!

this black.

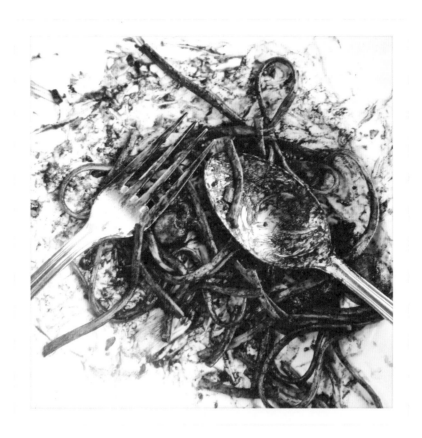

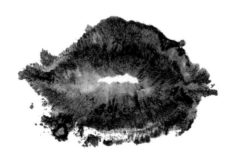

my big squid ink kiss.

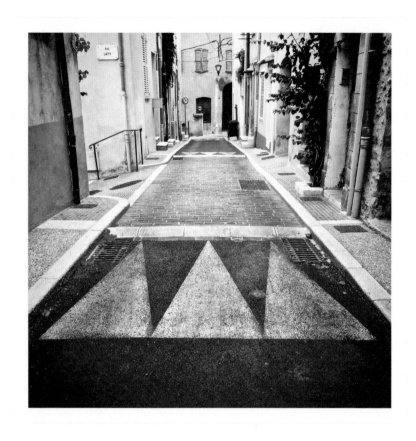

sometimes i'm inspired by things i see
on the street. . . .

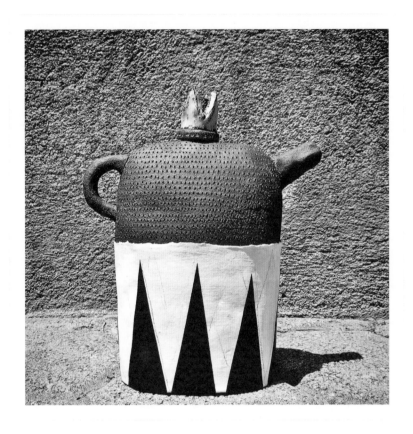

and sometimes i'm inspired by the
actual street.

BOCCE BALL

~~boules~~

PÉTANQUE

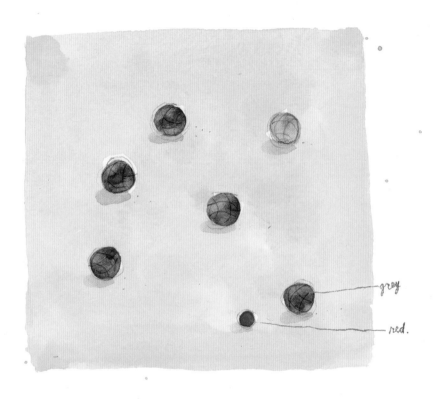

grey

red.

PÉTANQUE IS a GAME SORT OF LIKE BOCCE BALL
buT DiFFeRENT... aNd tHe BALLS aRe always MetaL.

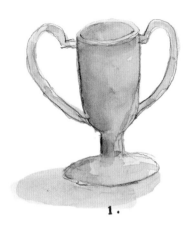

1.

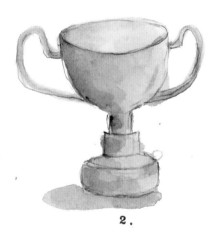

2.

Coupes de sports.

IN the HOME OF the LATE ARTIST JEAN DERVAL.
THESE UTENSILS WERE HANGING IN the KITCHEN.

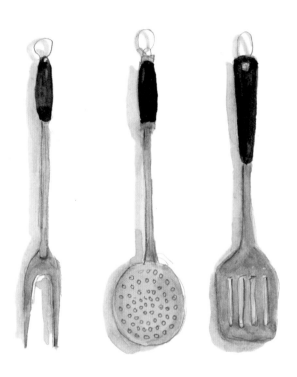

FRoMage StaiDay.

dark tan.

orange.

MiMoLette.

light
yellow

black

PePato PoiVre.

milky
yellow.

Gouda.

the STiNKieR... the BetteR.

We Had an Amazing FOUR HOUR LUNCH...

gazpacho.

grilled meats.

potatoes

tomato salad.

many cheeses.

..CHeZ LaURaNCe HiGH iN tHe HiLLs OF CaNNeS.

champagne.

wine.

espresso.

cakes, chocolate mousse, nougats.

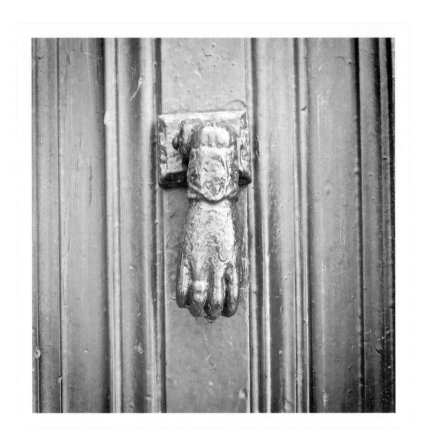

knock-knock.

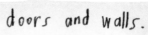

doors and walls.

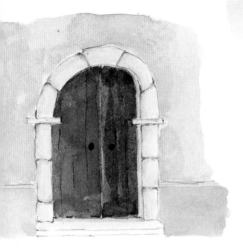

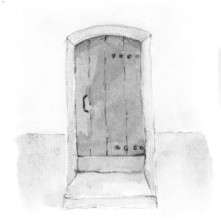

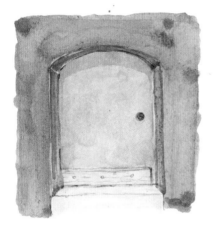

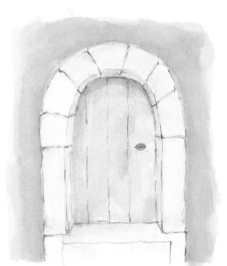

my favorite door in vallauris.

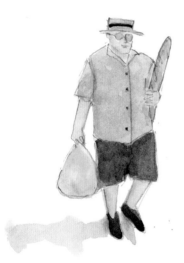

EVERyoNe iN tHe SoutH oF FraNCe waLks aRouNd
witH a BaGuette uNdeR tHeiR aRm.

Étude de Pain.

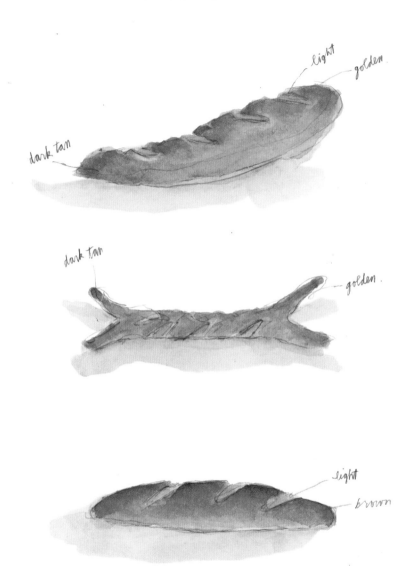

light

golden

dark tan

dark tan

golden.

light

brown

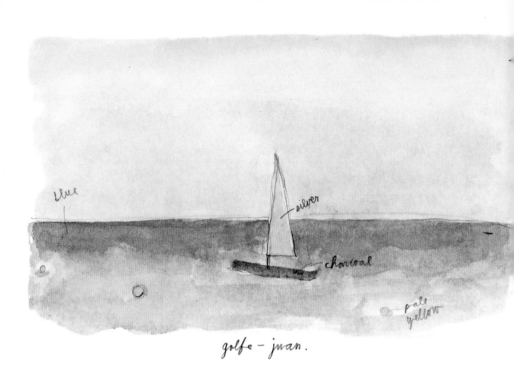

blue

silver

charcoal

pale yellow

golfe - juan.

petit sea glass findings.

the UMBRELLA study.

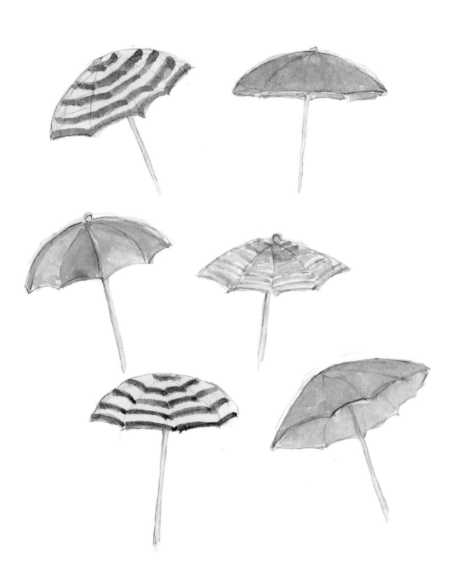

THESE ARE JUST *SOME* OF THE COLOR COMBINATIONS ON BUILDINGS IN VALLAURIS

aqua.
red brown.

forest.
grey.

dirty taupe.
pink.

pale yellow.
grey.

gold mustard.
dark taupe.

forest green.
dirty taupe

pale pink.
light brown.

salmon.
taupe.

brick red.
charcoal.

dirty pink.

mustard.

mint green.

dirty grey.

dirty peach.

beige.

brown.

dirty beige.

dirty blue.

red taupe.

pale blue.

taupe.

dirty green.

muddy orange.

dark salmon.

brown.

dirty mustard.

light taupe.

dark
forest

taking a ferry from cannes to a nearby island called île saint-honorat. this tiny island was founded in the year 410 by saint honoratus and is today occupied by 30 cistercian monks. they welcome visitors to the island but there are rules: modest dress. no cars. no noise. no smoking. this is my kind of island!

the original monastery is hauntingly
beautiful inside.

there is a 21 acre vineyard on île saint-honorat. the monks
wake up at 4:00 am to pray for 5 hours before working in
the fields or making wine and honey. i had the most
epic day on the island that began ~~with~~ with a sunday mass

knowing when to hang up my apron . . .

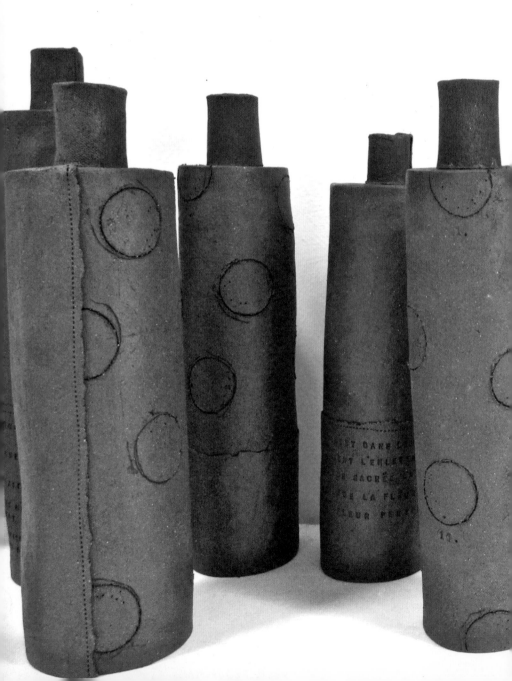

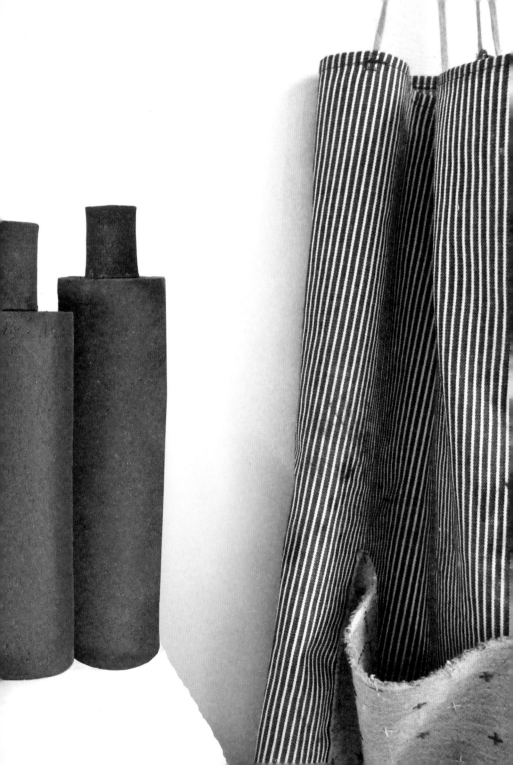

cream

milky
brown

crème de foie.

pink

white

brown.

côtelette de porc.

brown

pink
red.

rosbif.

charcuterie was wrapped up like
a present in this pretty paper.

1.

blue

gold

2.

gold

blue

pink flower

3.

mustard

pink

4.

pink

green

VeRy FaNCy TeaCups at
ViLLa EphRussi de RothsChiLd.

they all had gold RIMS.

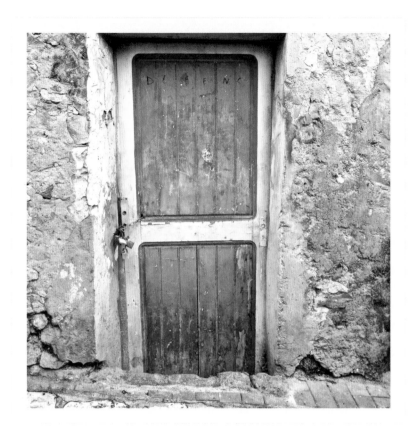

la porte bleue.

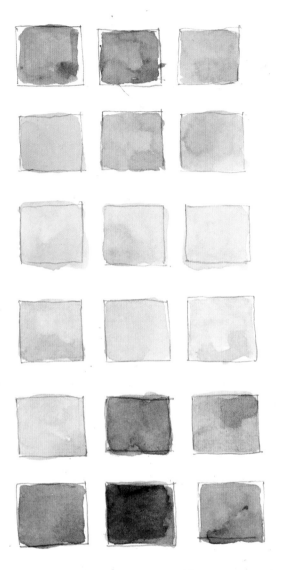

Les CouLeuRs de La MédiTeRRaNée.

painted on eden roc using
mediterranean sea for water.

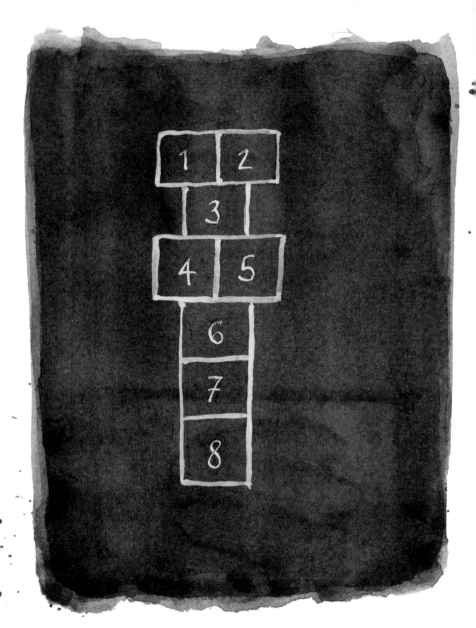

HOPSCOTCH ON the STREET IN VALLAURIS.

Musée Picasso.
antibes

black.

silver.

indigo

light blue

indigo

gold.

indigo

silver.

EVERYTIME I VISIT THIS MUSEUM I FEEL COMPELLED
TO SKETCH THESE PAINTINGS by ANNA-EVA BERGMAN.

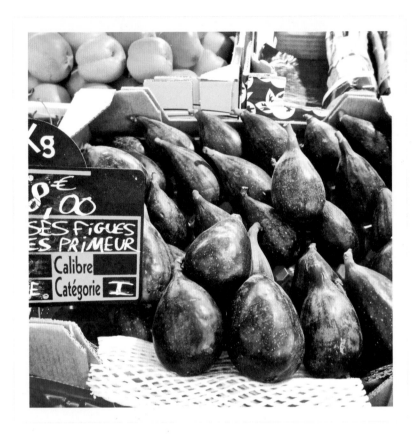

one day i ate SO many figs that i was
certain i would never want another. . . .
i was wrong.

La Figue.

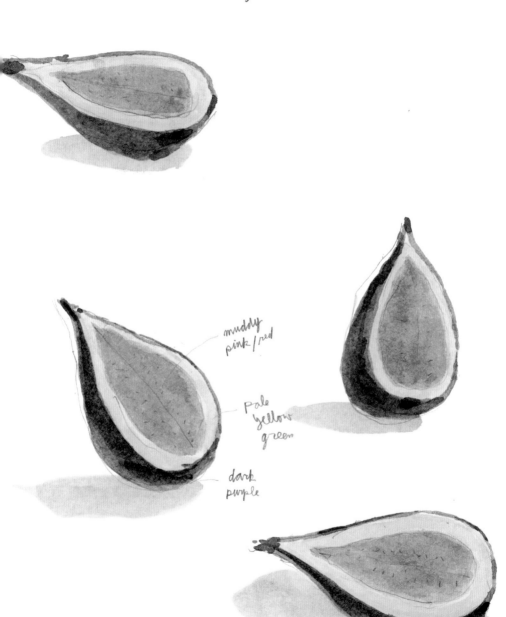

muddy
pink/red

pale
yellow
green

dark
purple

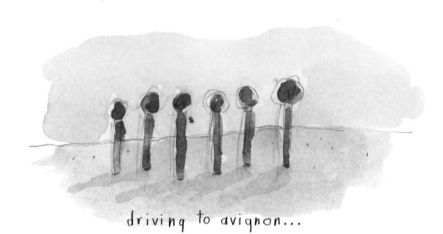

driving to avignon...

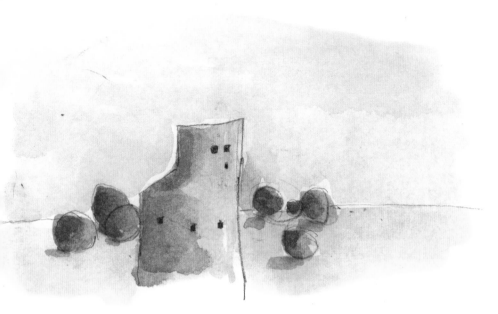

so much beautiful landscape.

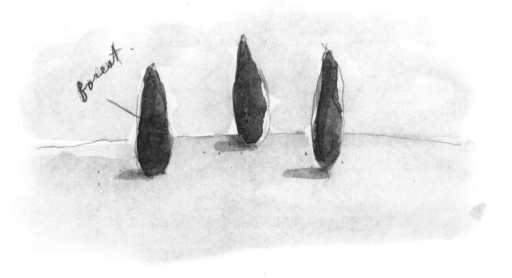

forest

the spooNs.

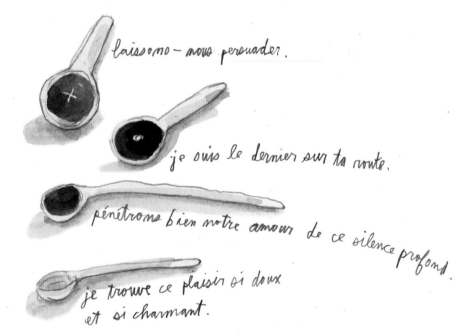

laissons-nous persuader.

je suis le dernier sur ta route.

pénétrons bien notre amour de ce silence profond.

je trouve ce plaisir si doux
et si charmant.

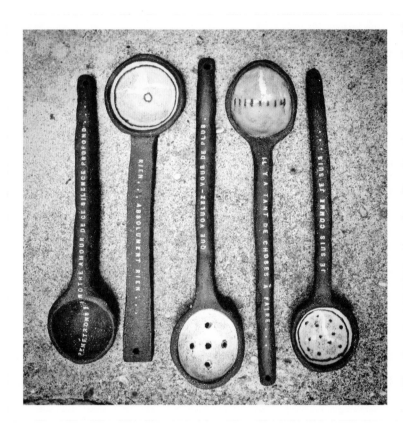

95

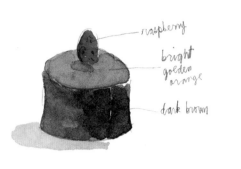

raspberry

bright
golden
orange

dark brown

dark
brown.

golden

dark
tan

dark
brown

milky
brown

dark brown

tan

light yel

caramel

tan

dark brown.

honey

yellow

white

brown

butterscotch

pale yellow

dark
brown

tan

white
powdery.

pale
yellow

tan

golden

pale
yellow

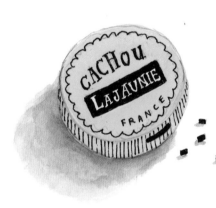

the BIGGEST little breath mint.

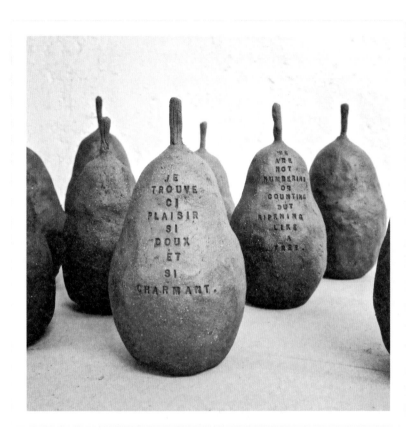

you can never have too
many pears. . . .

i ~~WANT~~ need these SHOES.

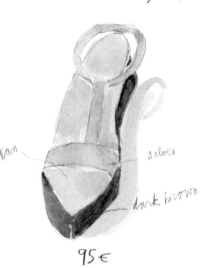

tan

silver

dark brown

95 €

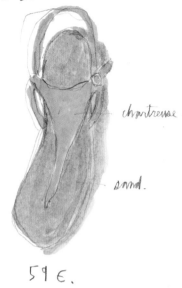

chartreuse

sand.

59 €.

brown

tan

85 €

black

tan

brown

90 €.

brown.

tan.

62 €.

pink

dark brown.

52 €

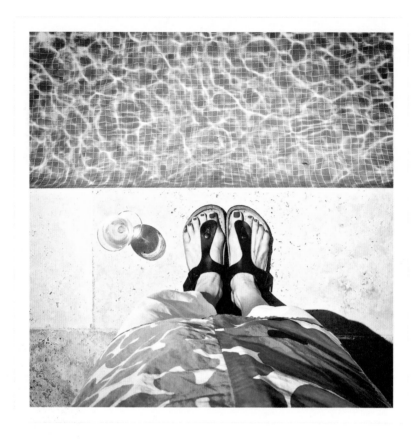

how to cool down in the south
of france.

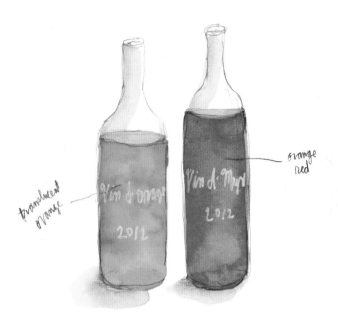

translucent
orange

orange
red

homemade vin d'orange
by ROBerto and GaBy.

LOQUats.
always remind me of my childhood.

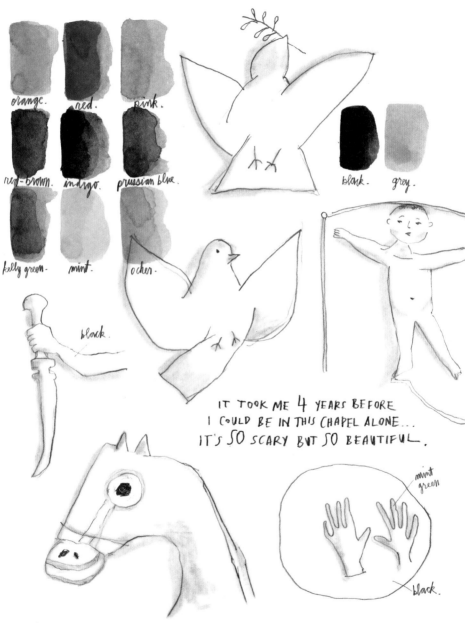

orange. red. pink.

red-brown. indigo. prussian blue.

black. grey.

kelly green. mint. ocher.

black.

IT TOOK ME 4 YEARS BEFORE
I COULD BE IN THIS CHAPEL ALONE...
IT'S SO SCARY BUT SO BEAUTIFUL.

mint green

black.

grey + black

MaN with a LaMb.
picasso

Picasso doNated tHiS SculptauRe to tHe toWN oF VaLLauRis. He LiVed tHeRe FroM 1948-1955 WHiLe WORKiNG at tHe CeRaMicS FaCtoRy MADOURA.

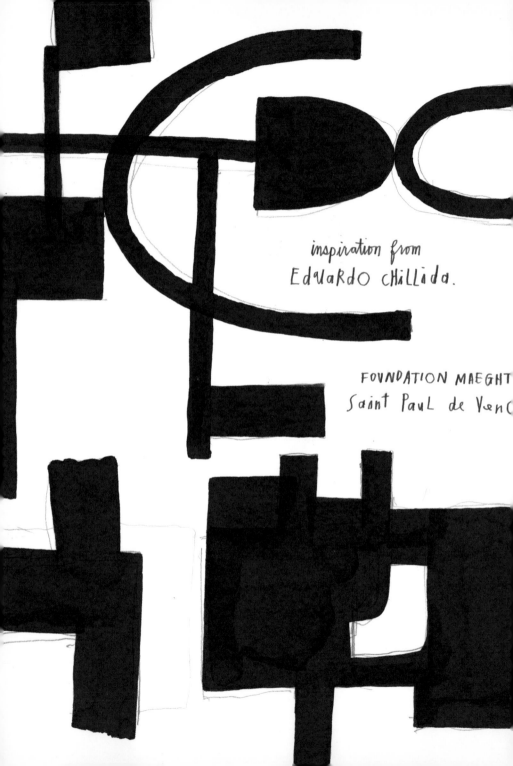

inspiration from
Eduardo Chillida.

FOUNDATION MAEGHT
Saint Paul de Venc

MARCHé PrOveNçaL.

olive study.

black — — milky purple

kalamata.

— green

provençale.

black — — dark green

— dark brown black

riviera.

— bright green

picholine.

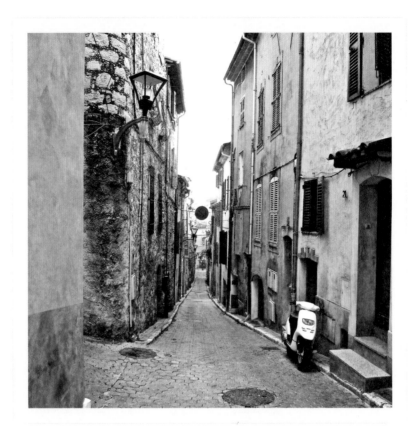

some of the streets are so narrow you
have to step into a doorway when a car
drives by.

Atte AbSiNtHe BaR.
antibes

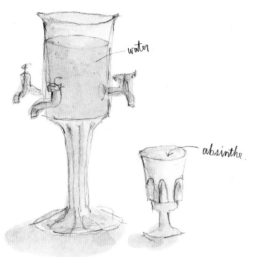

water

absinthe.

THE CONTAINER TO DRIP WATER INTO THE CUP.

light grey.

THERE WERE MANY HATS.

white.

SUGAR CUBE.

i bought these antique linens at the flea market in antibes.

this dog had a <u>GIANT</u> brown spot on his back.

red.

tan

grey

a Cigarette butt on the RED CARPET
at the CaNNeS FiLM FestiVaL.

the teapot.

add porcelain
slab. black
underglaze.

gold crown
on black
clay.

white slip
scratched
through.

porcelain slip.
black underglaze
painted over.

translucent
blue glaze circles
white words.

extra tall
light blue
glaze stripes.

glaze chalk.

white slip on
black clay.

half porcelain
half black clay.

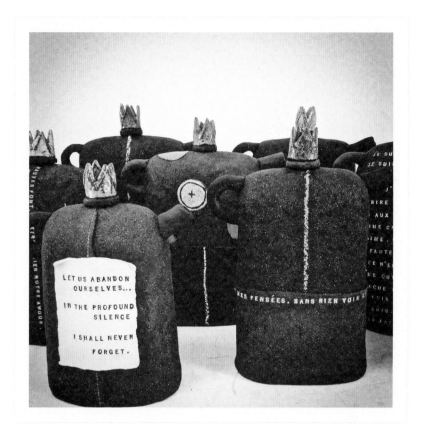

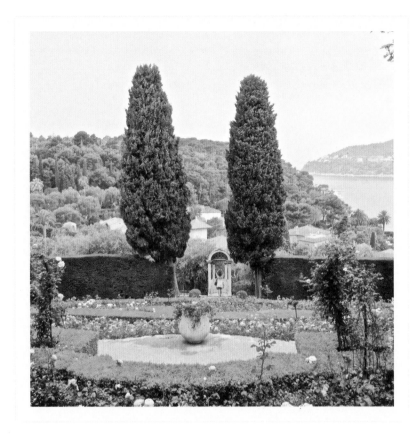

it is very easy to get lost in the
beauty of les jardins rothschild.

les Fleurs du Jardin Rothschild.

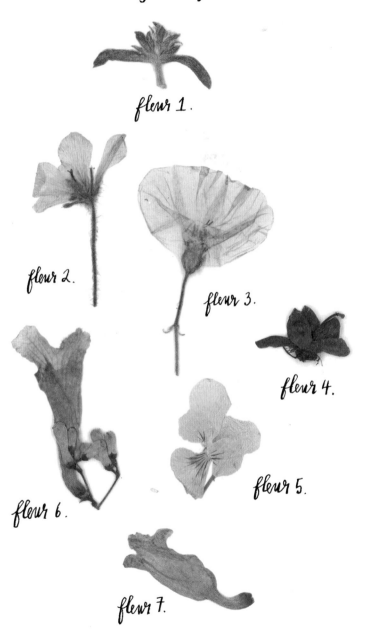

fleur 1.

fleur 2.

fleur 3.

fleur 4.

fleur 5.

fleur 6.

fleur 7.

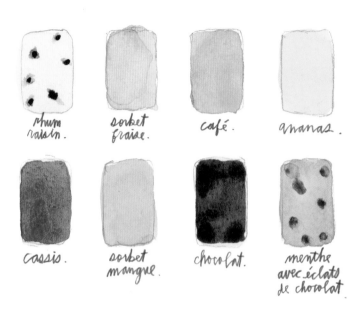

rhum
raisin.

sorbet
fraise.

café.

ananas.

cassis.

sorbet
mangue.

chocolat.

menthe
avec éclats
de chocolat

SoMetiMes i CHoose MY iCe CReAM
BaSed oN HoW PRetty tHe coloR is.

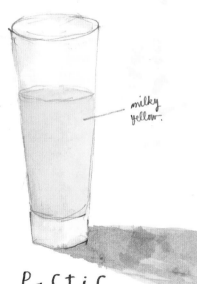

milky
yellow.

Pastis.
i drank many of
these at café du
coin.

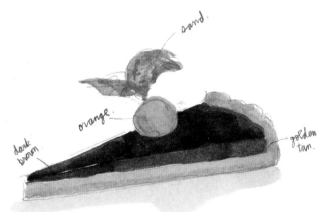

sand.

orange.

dark brown.

golden tan.

chocolate tart at café du coin.

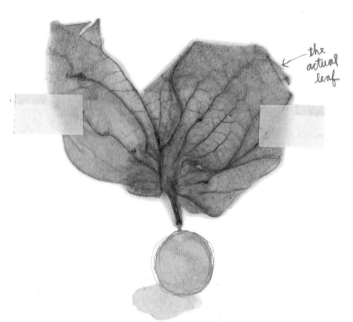

the actual leaf

this fruit is a PHYSALIS. it looks like a
tomato but tastes like a strawberry.

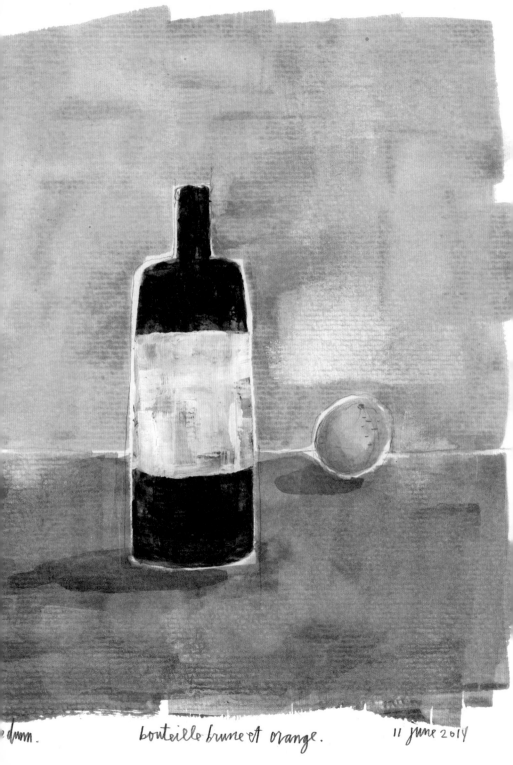

e dunn. bouteille brune et orange. 11 june 2014

PARFUM MAKING CLASS in GRASSE
@ GALIMARD.

Bus 600 grasse - cann
Bus 18 cannes - vallau

THERE ARE 127 DIFFERENT SMELLS.
THERE ARE 3 NOTES -

① PEAK NOTES: THIS IS the FIRST THING YOU SMELL. the
SMELL GOES AWAY VERY QUICKLY.
fresh. apple. citrus. mango. juicy fruits.

} top
20 min

② HEART NOTES: THIS IS the MAIN BODY OF the PARFUM.
THIS SMELL LASTS the LONGEST.
spices. cinnamon. heavy fruits. and ALL florals.

} middle
6-8 hour

③ FOND NOTES: THIS IS WHAT "FIXES" the PARFUM
TO YOUR SKIN. THESE SMELLS APPEAR AFTER
30 MINUTES. the HEART and FOND NOTES
MAKE UP the MAIN THEME OF A PARFUM.
heavy incense. woody. amber.

} base

lelle
elele
eleele

start with the FOND notes.

* BOIS MOUSSE. 15 ml
 BOISÉ CÈDRE. 15 ml
 MUSC FLORAL. 10 ml
 VANILLE. 5 ml
 FREESIA. 5 ml.
 MANGUE. 5 ml.
 FRUITS de CASSIS. 5 ml.
 THÉ VERT. 5 ml.
 COMPLEXE VERT. 5 ml.
 GARDENIA. X 3 5 ml
 BAMBOU. 5 ml
 JASMIN MUSQUÉ. 5 ml
 FLEUR de GRENADIER. 5 ml

i love these tiny bottles of smells.

ê t r e.

this is what i named my parfum.

* my secret recipe.

— LET the PARFUM SIT FOR A FEW
 WEEKS TO MARINATE...

THERE WERE SO MANY BEAUTIFUL PARFUM BOTTLES.

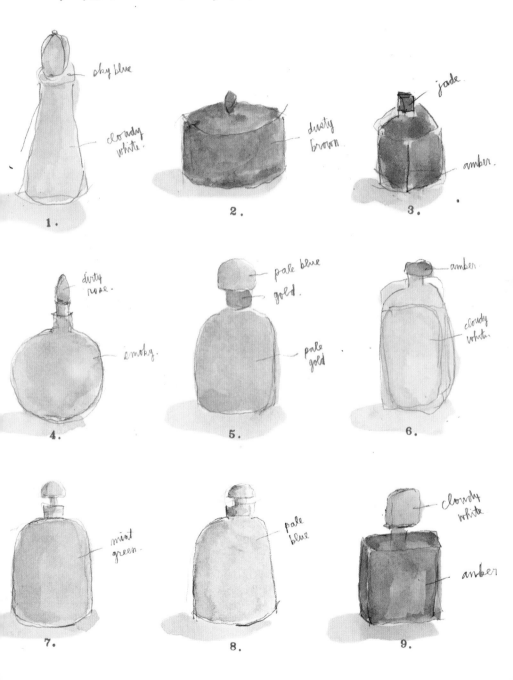

1.
sky blue
cloudy white.

2.
dusty brown

3.
jade
amber.

4.
dirty rose.
smoky.

5.
pale blue
gold.
pale gold

6.
amber
cloudy white.

7.
mint green.

8.
pale blue

9.
cloudy white
amber

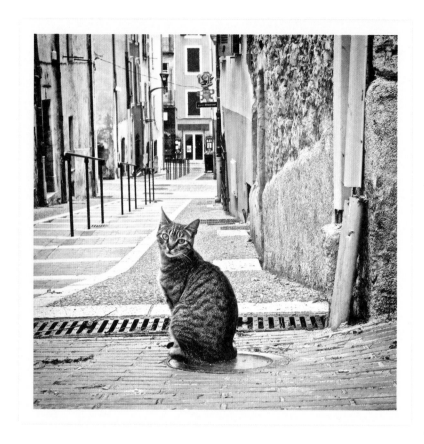

le petit chat BIT me when I
tried to pet him.

the FLEA market in NICE.

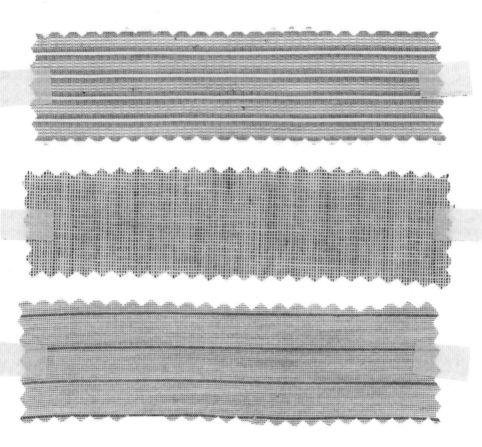

I BOUGHT THESE MEN'S SHIRTING FABRICS FROM A
LADY WHOSE GRANDFATHER HAD OWNED A TAILOR SHOP.

they will make cute aprons!

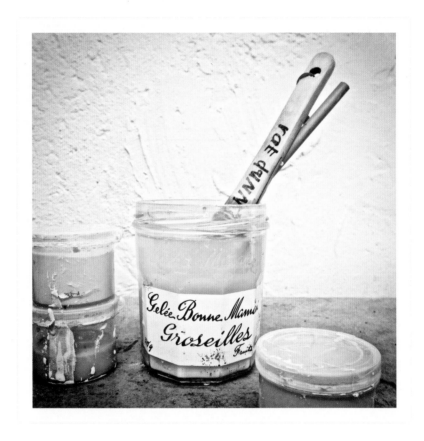

i found many uses for my empty jam
jars; this was the most useful.

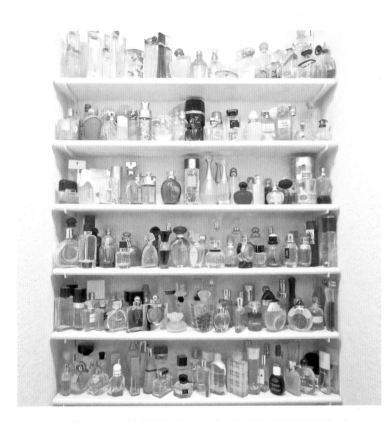

my friend, isabelle, has this
huge collection of parfum bottles in
her bathroom.

it's like a museum in there.

SO MANY SHADES OF ROSÉ.

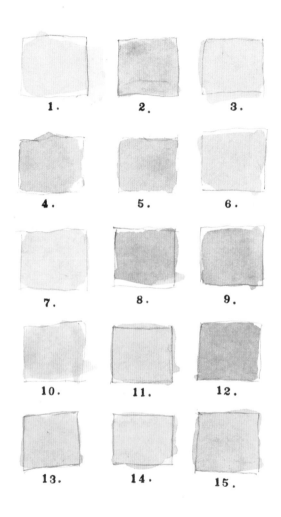

1. 2. 3.

4. 5. 6.

7. 8. 9.

10. 11. 12.

13. 14. 15.

NUMBER 7 IS MY FAVORITE.
SO PALE THAT IT'S ALMOST GREY.

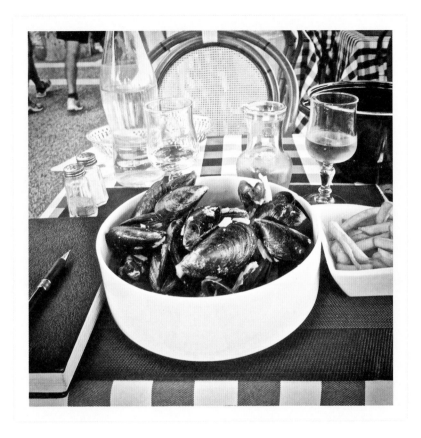

three of my favorite things to
do in france:

sketch. eat mussels. drink wine.

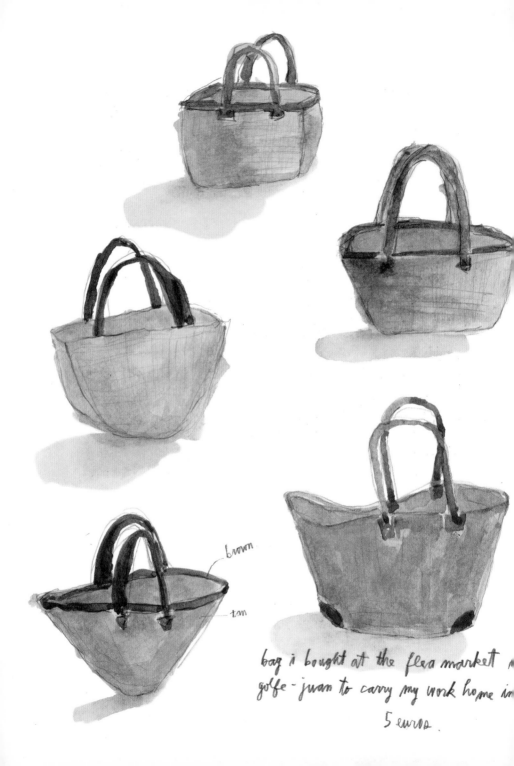

brown

tan

bag i bought at the flea market
golfe - juan to carry my work home in
5 euros.

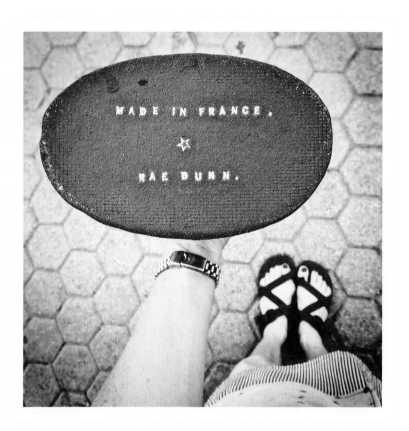

la fin.

People and places I'd like to thank:

Johnny Wow, Debra Lande, Bridget Watson Payne,
Stacey Bristol Lautenslager, my mom Connie Dunn (for
encouraging creativity from the very start), Dave and
Keay Wagner, studio dot's, Dale Dorosh, A.I.R. Vallauris
Residency, Polly Wagner, Wm. Levine, Anmy Leuthold,
Mickey Breitenstein, Lawrence Cowell, Corrie Dunn, Rick
Jow, Jackie Swoiskin, Stephanie Russo, Erin McGuiness,
Emily Payne, Kathleen Divney, Tamar Hurwitz, Rebecca
Bazell, Pouké Halpern, Laurence Duarte, Isabelle Vallet-
Lowerison, Cortland Lowerison, Chris and Joy Trevor,
Whitney Smith, Lisa Nappa, Dom Trapp, Beatrice Derval,
Roberto and Gaby Sussmeyer, Jean Michel, Mr. Digby,
Le Café du Coin, Musée Picasso——Antibes, Musée National
Picasso——Vallauris.

And a special thank you to the gentleman in Málaga who
stole my camera; I will forever see the world more closely.